A SINGULAR VISION

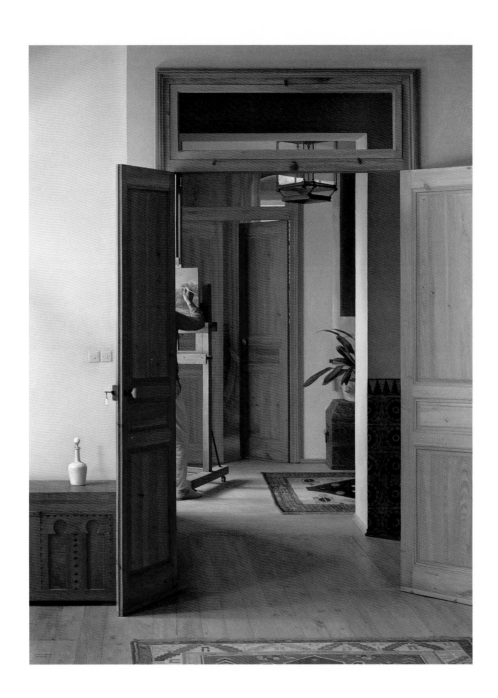

CHERYL BRUTVAN

A SINGULAR VISION

*Works from the Melvin Blake & Frank Purnell Collection
at the Museum of Fine Arts, Boston*

mfa

MFA PUBLICATIONS
a division of the Museum of Fine Arts, Boston

MFA PUBLICATIONS
a division of the Museum of Fine Arts, Boston
465 Huntington Avenue
Boston, Massachusetts 02115
www.mfa-publications.org

Published in conjunction with the exhibition "A Singular Vision: The Melvin Blake and Frank Purnell Legacy," organized by the Museum of Fine Arts, Boston, from February 4, 2003, to August 24, 2003.

For a complete listing of MFA Publications, please contact the publisher at the above address, or call 617 369 3438.

Frontispiece: Claudio Bravo, *Interior with Landscape Painter,* 1989
Cover illustration: Vincent Desiderio, *View of the City,* 1989 (detail)

ISBN 0-87846-657-6 (softcover)
Library of Congress Control Number: 2002114320

Designed by Mark Polizzotti

Available through D.A.P. / Distributed Art Publishers
155 Sixth Avenue, 2nd floor
New York, New York 10013
Tel.: 212 627 1999 · Fax: 212 627 9484

FIRST EDITION
Printed and bound in Singapore

Director's Foreword

꿈

WE OFTEN DESCRIBE the Museum of Fine Arts as a "collection of collections" and, significantly, the institution depended upon public-spirited Bostonians at its founding for the first acquisitions of art — all by gift rather than purchase. The late Melvin Blake and Frank Purnell of New York are the most recent examples of collectors to join a distinguished tradition of those who desired that a wider public benefit from art that brought them great personal joy. As one can see from viewing this important and highly personal collection, each work was selected not only for its individual beauty and meaning but also for its ability to relate to other art in the collectors' home. The paintings, drawings, and sculptures collected by Melvin Blake and Frank Purnell over four decades easily find relationships within our collection of European paintings and Classical sculpture and our holdings of modern works on paper. At the same time, this gift has made possible several new directions. For example, the extensive holdings of work by important members of the twentieth-century Spanish Realist school — notably Antonio López García — enhances our historical collection of

Spanish figurative painting. We find our first works by Surrealists Paul Delvaux and René Magritte in this gift, as well as our first painting by the esteemed British artist Lucian Freud.

We are grateful to the family of Melvin Blake, especially Ernest Blake and Martin Toyen, for providing the Museum with the opportunity to honor these distinguished collectors and present their vision to the world.

MALCOLM ROGERS

Ann and Graham Gund Director, Museum of Fine Arts, Boston

A SINGULAR VISION

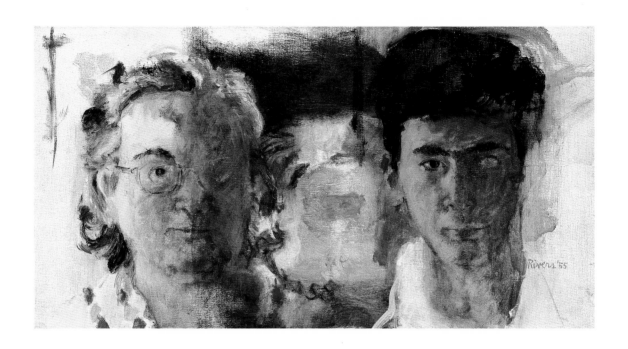

Larry Rivers, *Birdie and Joseph* (1955)

OVER A PERIOD of nearly four decades, Melvin Blake and Frank Purnell created a collection of drawings, paintings and sculpture that was appreciated for its singular vision and emphasis on the human form, as well as for its concentration on contemporary artists associated with the school of Spanish Realism. Medical doctors by profession (Blake was chief of dentistry and maxillofacial surgery at Lenox Hill Hospital in Manhattan from 1977 to 1989, and Purnell a highly regarded radiologist), both men admitted that they had only a passing interest in art when they moved to New York in the early 1960s. However, it was fate that tapped their unsuspected enthusiasm when the dealer George Staempfli set up his first gallery near their offices.

Although galleries abounded in the area around the East Seventies and Madison, Blake and Purnell found that their most comfortable relationship was with Staempfli, who had been a curator of paintings at the Museum of Fine Arts in Houston and worked at the esteemed M. Knoedler & Co. before establishing his own gallery in 1959. Of Swiss origin, Staempfli represented both American and European artists,

with a pronounced interest in figurative painters during a time when abstraction was increasingly geometric (and, to some, inhuman), and when Pop Art was developing its own daring use of recognizable imagery. Among the artists he championed were the designer and sculptor Harry Bertoia, the Belgian Surrealist Paul Delvaux, and a number of Spanish Realists, such as Antonio López García. Staempfli appears to have profoundly influenced Blake and Purnell, who in turn would introduce the dealer to a discovery of their own, Claudio Bravo. It was at Staempfli's that Bravo received his first solo exhibition in New York in 1970.[1]

In general, the artworks Blake and Purnell selected are contemplative and display a great sensitivity to the human form — both exceptional characteristics for the period in which the collection was realized. Yet Blake and Purnell also delighted in work that pushed the boundaries of generally acceptable taste in America at that time. Among their provocative choices, they acquired one of Larry Rivers's controversial paintings of nudes, *Bedroom* (1955), believing that its scandalous history included rejection from an exhibition at the Whitney Museum of American Art. They also took pleasure in the story of the difficulties that Staempfli encountered with U. S. Customs in 1959 over

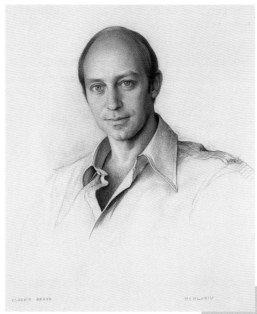

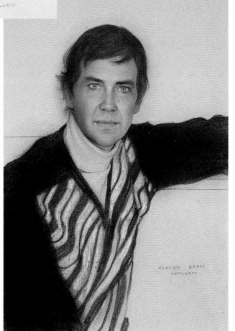

TOP: Claudio Bravo, *Mel* (1974)
RIGHT: Claudio Bravo, *Frank* (1974)

11

works by Paul Delvaux. And they faced their own challenges with Customs when bringing López García's somber painting *Atocha* (1964) into the country after acquiring it in Spain. Speaking about their acquisitions in 1994, they recalled:

> There has evolved a certain tone to the collection and, while there are several artists whom we admire, we found their works did not fit with the rest of the collection . . . The current fads of the art world have never influenced our purchases; nor have we been swayed by advice from art consultants or from professional curators. Ultimately, it is our aesthetic sensibilities, intellectual pursuits, personalities and life style that combine to determine what works we acquire. As a result, the totality of what is displayed mirrors its owners.[2]

One might discern an undercurrent of eroticism in much of the figurative work, which predominantly depicts the male human form, often unclothed. Yet, except for López García's metaphorical *Atocha*, the images are of solitary figures rendered with a classical sensibility and, even, distance between viewer and subject. A stillness pervades

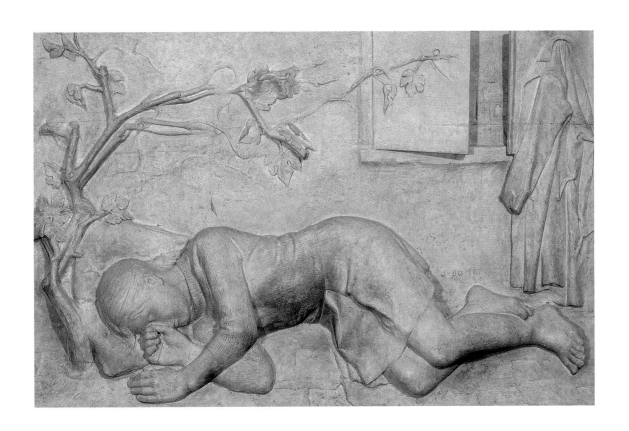

Julio Hernandez, *La Primavera* (1970)

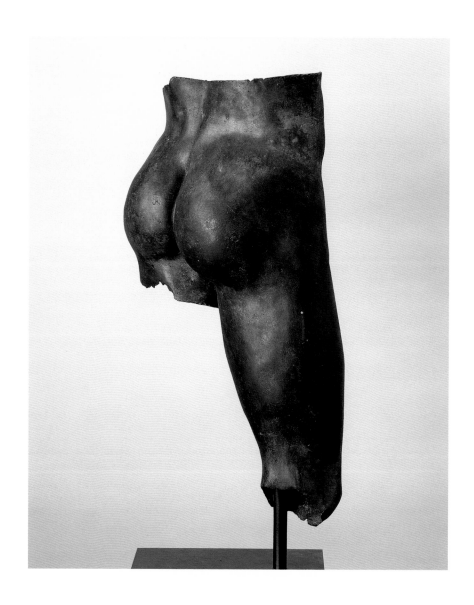

Torso of a Youth, Roman, 2nd century A.D.

these works that, for all their attention to flesh and humanity, are quiet in expression.

Given this firmly established sensibility, it seems logical that in the early 1980s Blake and Purnell should turn their attention to antiquities — less for their provenance, according to the collectors, than for their beauty. The serene bronze sculpture the MFA has acquired, a fragment of a life size *Torso of a Youth* from the second century A.D. is rare not only for its scale and the superb control of the artist, but for its very survival: bronze was typically melted down for weapons and coins.

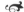

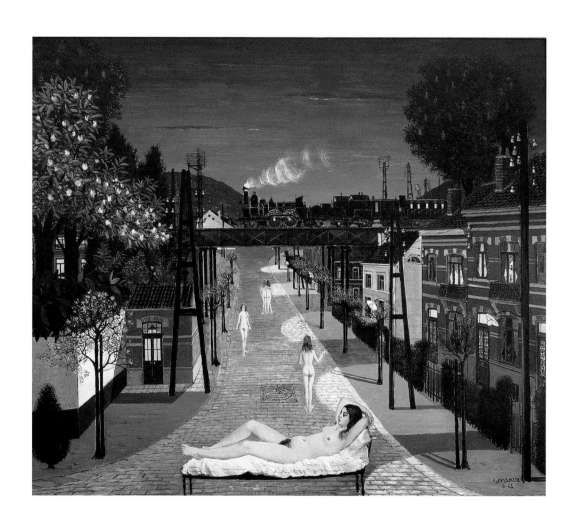

Paul Delvaux, *Le Printemps* (1961)

THE SERENITY THAT Blake and Purnell found in classical sculpture is also apparent in the paintings and drawings that dominate their collection, and particularly in the figures that inhabit the paintings of the Belgian artist Paul Delvaux (1897–1994). Very early in their collecting, Blake and Purnell acquired three canvases representing the early, mature, and late phases of this artist's work. By the mid-1930s, Delvaux had found his signature motif of clearly defined and indifferent nude figures placed in unexpected, empty, or decaying urban settings. The disturbing undercurrent of Delvaux's paintings largely accounts for his general association with the Surrealists, many of whom found the distorted human forms and overt sexuality essential expressions of the subconscious. For Delvaux, however, the silent, inactive sculptural figures — predominantly women — and their unlikely surroundings were meant not only to relate the fears and mysteries of childhood, but also to act as symbols of the adult's inescapable anxieties in a solemn but often arousing manner. "Naturally there is eroticism," Delvaux once remarked. "Without eroticism I would find painting impossible. The

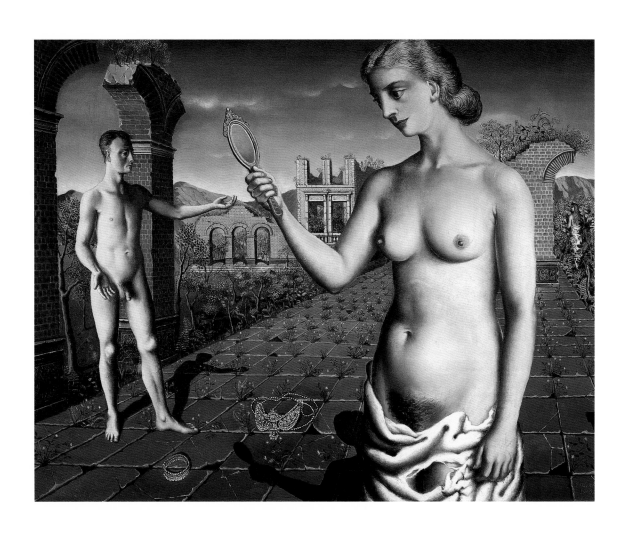

Paul Delvaux, *Proposition diurne (La femme au miroir)* (1937)

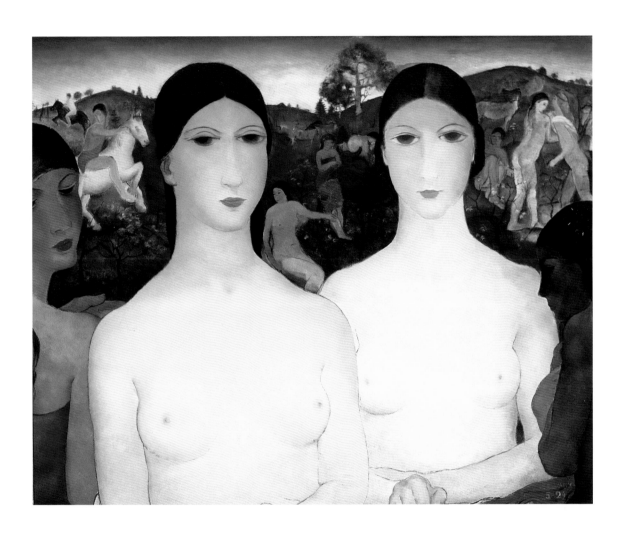

Paul Delvaux, *Rose et blanc* (1929)

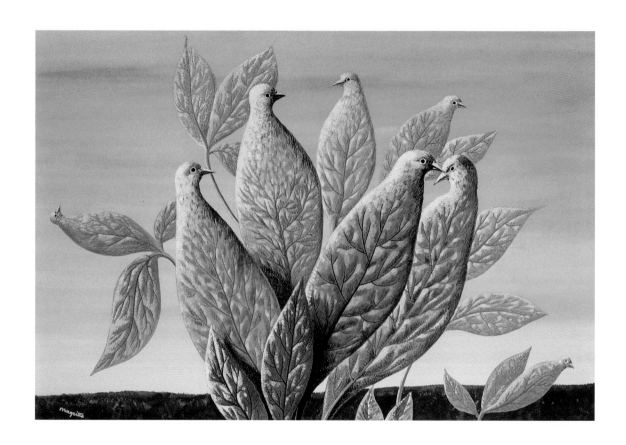

René Magritte, *Les Graces naturelles* (1942)

painting of the nude in particular. A nude is erotic — even when indifferent, when glacial. What else would it be? The eroticism of my work resides in its evocation of youth and desire."[3]

Proposition diurne (La femme au miroir) (1937) dates from the period when Delvaux first arrived at his signature style. In the foreground of a garden surrounded by stone ruins stands a mature woman with only a torn cloth wrapped below her torso; her characteristics — wide eyes, golden hair and full form — would become familiar in the artist's oeuvre. The mirror she holds in her hand does not reflect her face but remains as empty as her expression; she is unmoved by the gesturing of a nearby nude man with perfectly coiffed hair, equally oblivious to her and the jewels strewn on the ground between them. Theatrical and haunting, Delvaux's painting succeeds in displaying the unobtainable, expressing fear and desire without demanding attention to the artist's role as creator.

Just as these paintings by Delvaux represent classic examples of the artist's work, so *Les Graces naturelles* (1942), a gouache on paper by another notable Belgian Surrealist, René Magritte (1898–1967), is characteristic of that artist. Against a pink background is a "leaf-bird" family, a typical motif for Magritte in the year 1942. It appears in other works on

paper, where the "family" is given a context, and seems to grow out of an island in the 1942 oil painting *L'île au trésor (Treasure Island).* Years later Magritte would also use the image for bronze sculptures.

IT IS IN ITS EMPHASIS on the works of the Spanish Realist School that this collection earns its major distinction. Reflecting on their years of collecting, Blake and Purnell recalled Antonio López García's first exhibition at the Staempfli Gallery in 1965 as a revelation. Their interest in López García and his contemporaries was aided not only by Staempfli, however, but also by the Madrid dealers Juana Mordo and Enrique Gomez Acebo, whom they met as early as 1967, and who introduced them to Quintas, Muñoz, Lledo, Laffon, Quetglas, and others. This interest, which seeks out a form of realism unlike the then-dominant taste for "Pop Art" and photo-realism in America, says much about the independence and confidence that distinguished these collectors.

The critic William Dyckes has identified in Spanish Realism a "kind of dominant national character, an attitude toward technique and content that is identifiably Spanish," and that he directly attributes to "the central facts of Spanish life: isolation and tradition." A regard for technical facility and truth of the depicted subject, which itself was most often found in the humble surroundings of the artist's world, are hall-

marks of this school and can perhaps be traced back to such seven-teenth-century artists as Francisco de Zurbarán and Jusepe de Ribera.[4] What aligns these modern artists is a type of realism that emphasizes atmosphere and the evocative power of light, rather than dramatic scenes, as well as their attention to extraordinary detail and trompe l'oeil effects (as one might expect from the categorization of their work). While they share an interest in that which is known, in the familiar, each artist has developed a style revealing a depth of understanding that pro-pels their work beyond regional style. In these works, the mundane sur-roundings of life speak with universal resonance.

López García is a cornerstone of the Blake–Purnell Collection, in which he is represented by two drawings, four paintings, and two wood reliefs — a gathering that becomes all the more impressive when one knows that López García can take years to complete a single work. His extraordinary sensitivity and faithfulness to light — an essential and integral element and, often, the reason he chooses such seemingly ordi-nary subjects — demands that he put away a piece until the same time of year when the desired light can be viewed again. The artist's love of sculpture and devotion to modeling form, even in paint, is evident in the early painting *Hombre y mujer* (1964; also known as *A Back*). The first

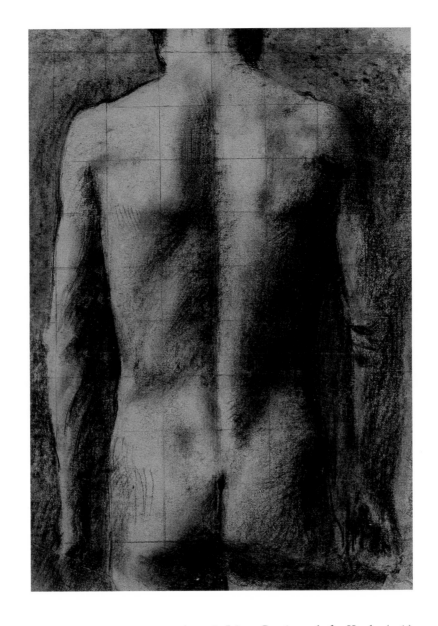

Antonio López García, study for *Hombre* (1963)

OVERLEAVES: Antonio López García, *Hombre y mujer* (1964)

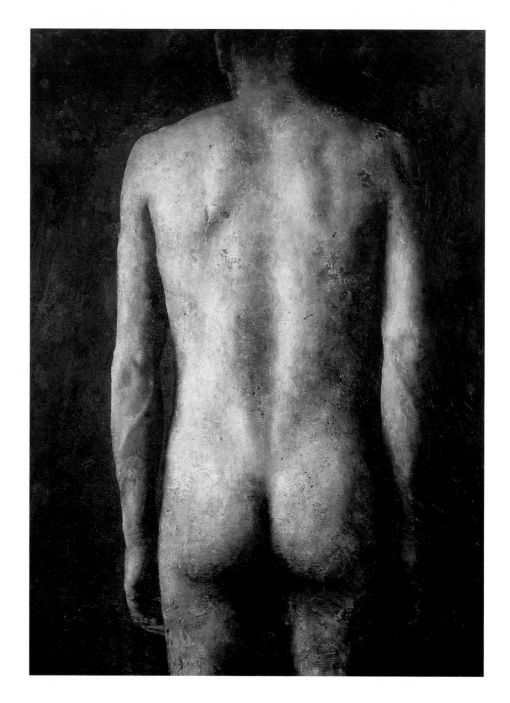

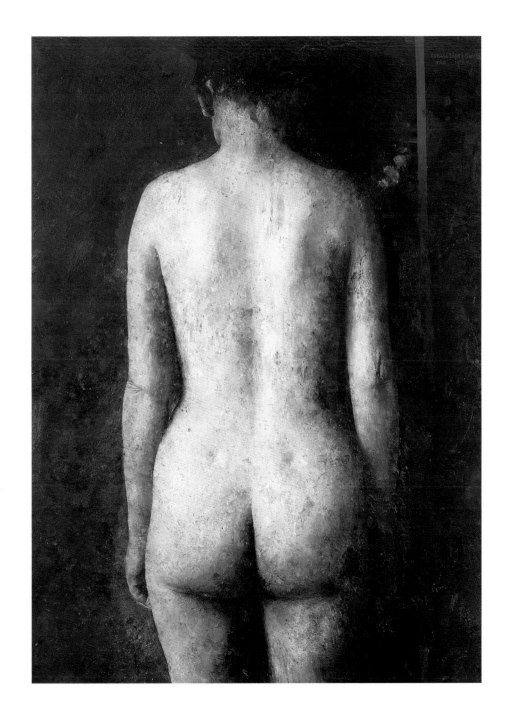

work Blake and Purnell acquired of his, at the artist's 1965 New York exhibition, *Hombre y mujer* shows the backs of a naked man and woman, sculpted by the play of subtle light across their ordinary flesh. These bodies are not idealized figures nor posed with formality nor lit to enhance and soften flaws that exist in all of us. Rather, they appear to be willing subjects who simply turned around as requested by the artist, who was most intrigued by the light on these human forms. They appear to take shape from the shadows, rendered with an extraordinary sensitivity to their surfaces. Skin is not only subject here, but also the term López García applies to the surface of all of his paintings, which are far more than a simple illusion made of pigment on canvas:

> The base I use consists of board, or canvas stuck on board, because I need an unyielding surface with considerable body which can stand up to anything I may do to it . . . It's a very long struggle . . . It involves a constant debate with the language of painting, constantly applying and removing the materials, until the surface, that skin, becomes expressive and reconstructs or approximates what I see.[5]

Atocha (Esparto) (1964) is another early work, similar in atmosphere to *Hombre y mujer*. But the couple's engagement in a sexual act in the foreground of this empty corner of a city makes this one of López García's most psychologically and emotionally charged works. It remains singular in his oeuvre for the reality of the couple's actions and the believable environment in which they are placed. Before this, paintings such as *Ataud (Niña muerta)* (1957) included juxtapositions that might entail a more magical interpretation of the characters in their urban settings. Evolving from a depiction that is more stylized than objective, the surfaces of these earlier works appear aged, much like the frescoes the artist admired in Pompeii. But his eventual reliance upon the familiar — he often paints the city of Madrid, where he has lived since 1960 — has resulted in a style that is identifiably López García's. It is as if the artist has given form to the abstract, depicted not so much an object as the atmosphere and character that surrounds that object. In *Atocha*, he directs the same penetrating observation given to other images from the early 1960s (such as a rose garden, a solitary sideboard, or remarkable aerial view of New York) at both the couple and the barren city in which he has placed them. The title of the work is taken from the name of the central railroad station in Madrid; here the inhospitable

surroundings act as a backdrop rather than as shelter. Yet rather than showing fear and vulnerability, the couple in *Atocha* demonstrates an unexpected comfort with their intimacy in this concrete setting — perhaps revealing López García's own relationship with the city that has surrounded him and provided the setting for his career as an artist.

More personal is a 1967 painting, *Lavabo y espejo (Washbasin and Mirror),* one of a group of works in which the most hidden and unromantic intimacy of daily routine becomes the vehicle for a challenging depiction of subtle light in a nearly monochromatic composition. Both a still life and a self portrait, this work exudes a feeling less of being closely observed than of sharing an unspoken intimacy based on use and everyday experience. *Percha con ropa (Clothes Rack)* from 1963-64 carries a similar feeling of intimacy resulting from familiarity. In this further, rare instance of self portraiture, López García incorporated an actual door and handle into a composition based on his own clothes. As sculptural forms, these worn and familiar articles are a surrogate for the artist's body, offering the viewer a greater intimacy than the illusion of a two-dimensional painted likeness.

López García easily moves between sculpture and painting, while recognizing which medium best serves his objective: "I have created

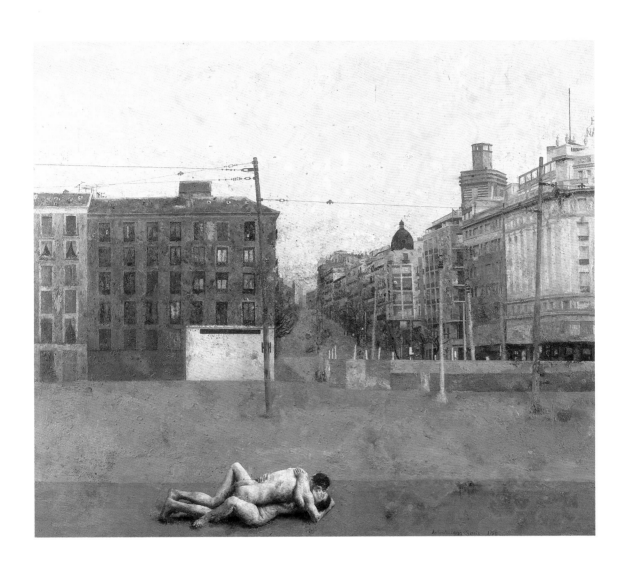

Antonio López García, *Atocha (Esparto)* (1964)

Antonio López García, study for *Atocha* (1964)

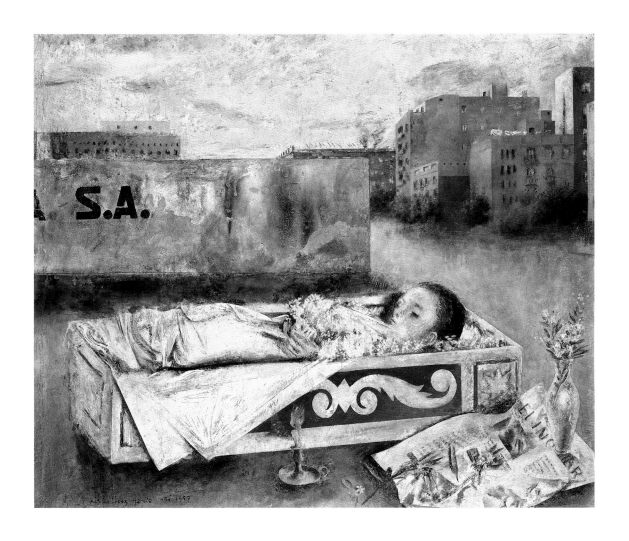

Antonio López García, *Ataud (Niña muerta)* (1957)

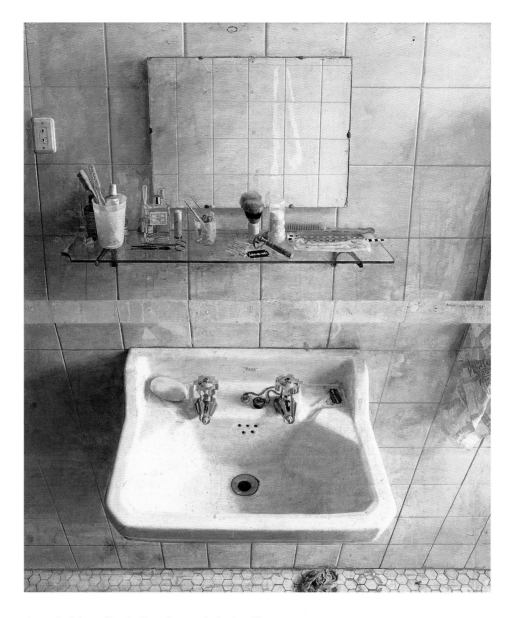

Antonio López García, *Lavabo y espejo* (1967–68)

OPPOSITE PAGE: Antonio López García, *Percha con ropa (Clothes Rack)* (1963–64)

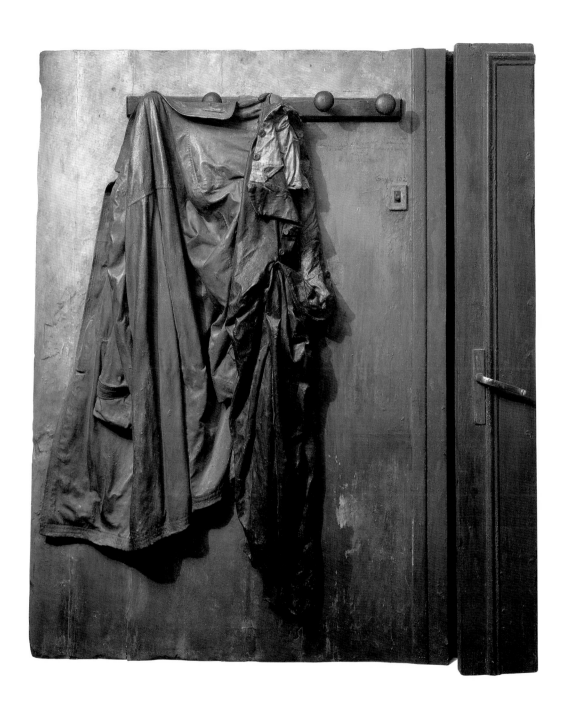

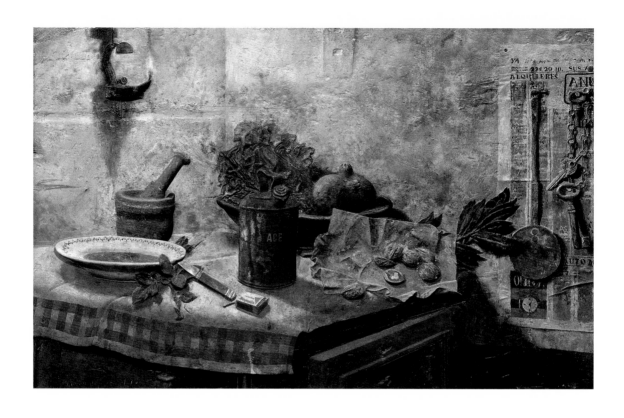

Antonio López García, *La Fresquera (Bodegon)* (1960–63)

pictures from the form of things, from their volume, their materiality and from the distance between the different planes, rather than from color," he once told an interviewer. "This is probably what has enabled me to produce sculpture — perhaps not that of a true sculptor, but the kind I need to make. For a long time now I have conceived the human figure in terms of how I would model it, sculpturally; other subjects, landscapes for example, I think of how I would paint them."[6]

6

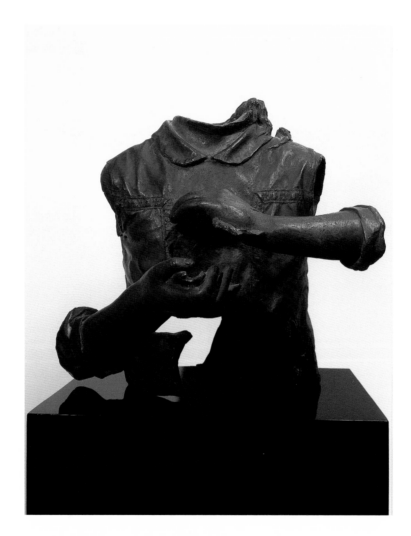

Julio Hernandez, *Tesoro de Marcella* (1971)

Both Julio Hernandez and Lucio Muñoz were a year ahead of López García at school in Madrid and both work primarily in sculpture, though in distinctively different styles. Hernandez is more closely aligned with the realist tradition and recognized for an emphasis on space and the emotional potential of his compositions rather than for the play of light on form.[7] In *Tesoro de Marcella* (1971), an extraordinary cast in bronze, he uses the power of gesture and a hollow figurative form to create both mystery and tension. The unattached arms and undefined treasure held in the figure's hands seem a reinvention of the fragmentary appearance that we have come to accept in ancient classical figures.

Lucio Muñoz studied in Paris and was exposed to the aesthetics of Art Informel, which maintained an adherence to formal qualities but emphasized a more spontaneous approach to composition. Less literal and more abstract than the work of his Spanish peers, Muñoz's "Pseudo-paintings" (as he called them) resulted from a physical approach and emphasis on the texture of his materials, especially wood. Rather than

use wood as a support or material to be carved, Muñoz burned and dug into the surface, assembling the varied passages that might then be covered with paint to create a more physically expressive composition. The expression of Muñoz's door, in *La Porta* (1965), stands in stark contrast to López García's *Percha con ropa*, although they both derive from the same materials.

Drawings and watercolors represent the work of many other Spanish artists in this collection. Isabel Quintanilla resides in Madrid and is clearly in harmony with the work of her contemporary López García. She, too, is regarded for her skillful definition of interiors and objects from her immediate and humble world. Her drawings, such as *Entry* (1970), relate her own manner of defining form with a subtle yet exceptional handling of light on surfaces. A sense of solitude and stillness pervades her work, as it does López García's. Another artist, Carmen Laffon, studied in her native Seville before attending the same fine arts school in Madrid as did the Spanish Realist artists of her generation. In *Maria* (1972-73), her interest in imagery based on dreams and memories blends with her acute observation of believable surroundings. Once again, the simplicity of the scene is in contrast to the artist's masterful handling of light, defined through her skillful applica-

tion of charcoal. Laffon illuminates, through a range of tones from black to white, the lace on a coverlet while modeling the subject's presence out of shadow. Despite the large scale of this work, for which Laffon pieced together several pages of paper to create her support, the intimacy of the composition is not lost.

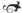

Lucio Muñoz, *La Porta* (1965)

Guillermo Lledo, *Landscape* (1973)

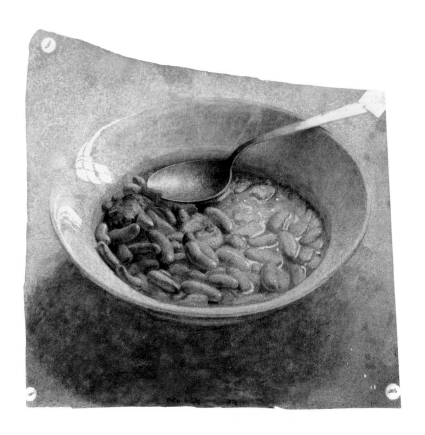

Matias Quetglas, *Garbonzo* (1978)

OPPOSITE PAGE: Matias Quetglas, *Poppy Field* (1971)

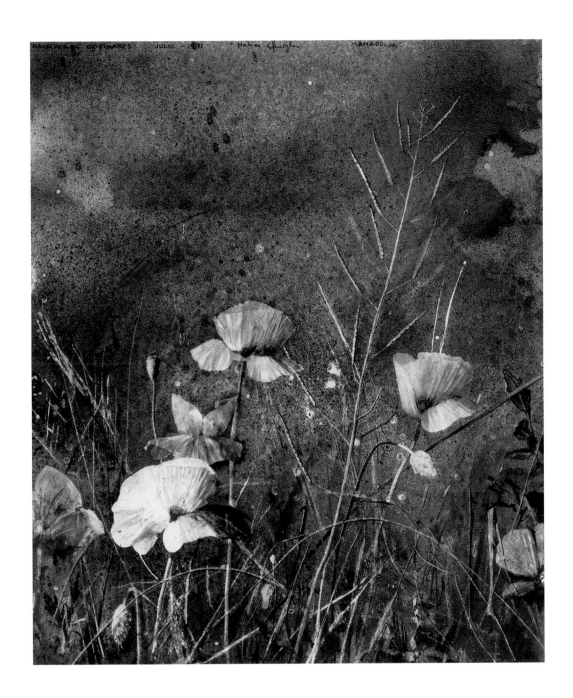

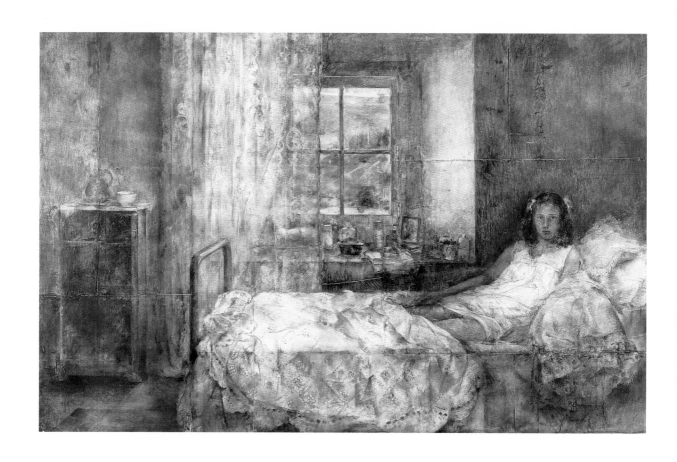

Carmen Laffon, *Maria* (1972–73)

OPPOSITE PAGE: Isabel Quintanilla, *Entry* (1970)

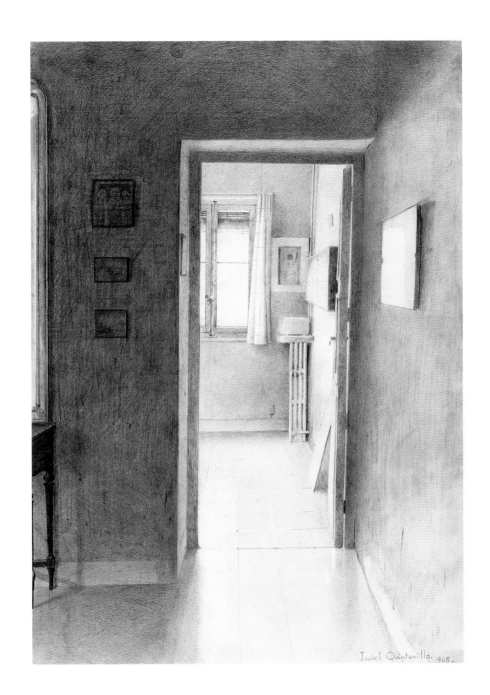

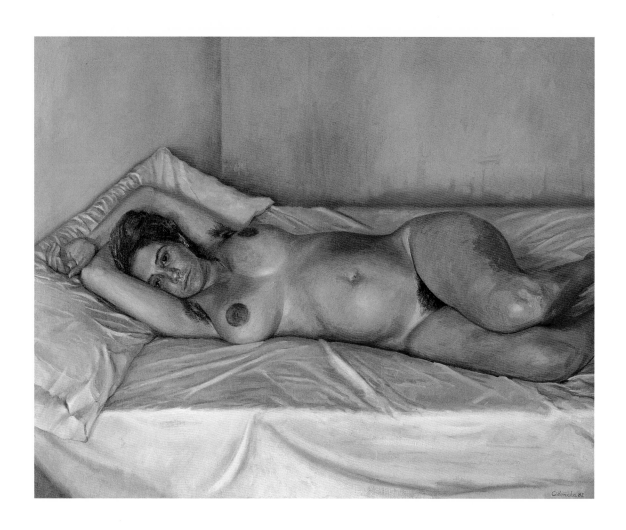

Rafael Cidoncha, *Pregnant Nude* (1982)

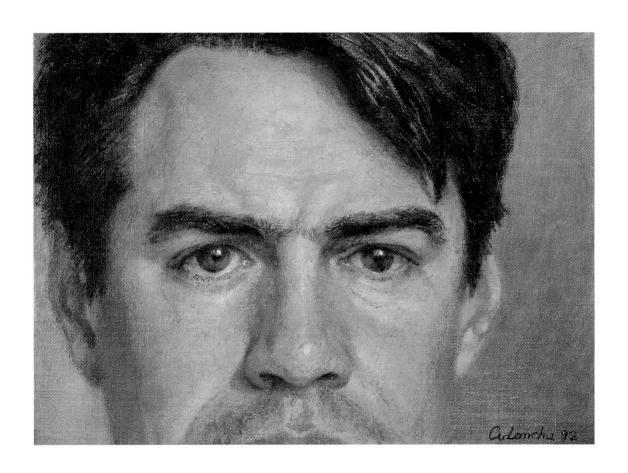

Rafael Cidoncha, *Self Portrait* (1992)

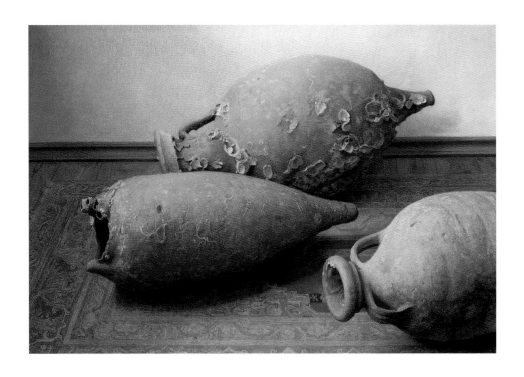

Claudio Bravo, *Roman Jars* (1991)

UNDOUBTEDLY, ONE OF THE MOST prominent figures in the collection of Melvin Blake and Frank Purnell is the Chilean-born artist Claudio Bravo, from whom they acquired drawings, paintings, and two bronze sculptures. Their association was of mutual respect and admiration, a reflection of the deep friendship that developed between artist and collectors over the years. Blake and Purnell were first exposed to one of Bravo's "package paintings," a challenging and critically admired subject, in 1969 at the home of a friend. "Intrigued with his technique and skill," they determined to meet Bravo that same year, and were surprised to find that he had already achieved great success and a comfortable lifestyle, owing to the demand for his work as a portraitist. While an exceptional ability to depict "reality" ties Bravo's work with that of the Spanish Realists, his canvases eschew the poignancy and haunting atmospheric qualities characteristic of the others' work. Instead, Bravo revels in color and a precise definition of his forms, emphasizing his extraordinary skills as a draughtsman. But it is the desire to accurately create an illusion of reality that compels him

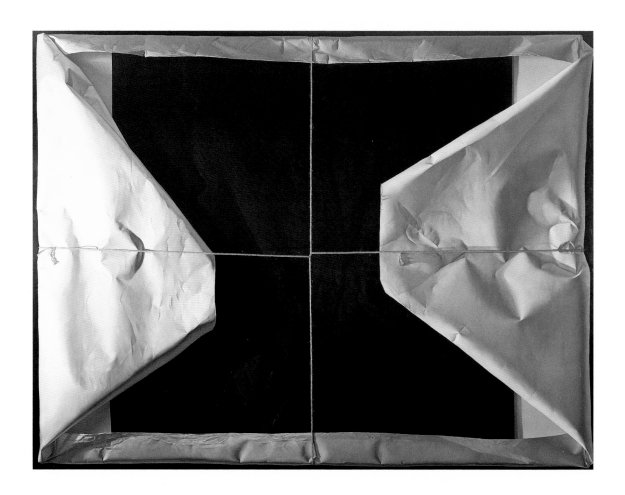

Claudio Bravo, *Homage to St. Theresa* (1969)

above all: "I'll always be a realist," he has said. "I'm always studying color more and more closely. With a refined sensibility of color, I will be able to make the things I paint appear even more real. I'd like to make them almost jump off the canvas."[8]

The abstraction of the package paintings is rare in Bravo's career. The artist set out to create a trompe l'oeil effect with this series, something he successfully achieved in the drawing *Can You Package Air?* (1969) and in the large image of a wrapped painting from the same year, *Homage to St. Theresa*. Bravo is aware of the work of his peers, and has acknowledged that the package paintings were partly inspired by the abstract color field paintings of Mark Rothko, as well as (in the use of actual string across a surface) by the Spanish artist Antoni Tàpies, whose abstract paintings and sculpture included elements from the gritty world around him. Trompe l'oeil effects are found throughout the history of painting. Yet the subdued palette of some of these works, and the emphasis on such casual, ordinary materials as paper and string, cleverly acknowledges the interests of Bravo's international peers at a time when the relevance of illusion and representation in painting was exchanged for an emphasis on the inherent physical qualities of non-traditional artistic materials. Minimalism and conceptualism reigned.

More typical of Bravo's work are his depictions of the human form and still-lifes. The powerful *Portrait of Mr. Couchez* (1978) and the grand *Vanitas* (1981) reveal not only Bravo's powers of observation but also his admiration of classical references and of the artistic tradition of seventeenth century Spain, for which Bravo feels the greatest affinity. *Portrait of Mr. Couchez*, also titled *Black Nude*, is a nearly life-size canvas of a statuesque nude man. Although Bravo acknowledges the presence of the erotic in some of his work, this particular figure study is neither pornographic nor especially revealing. Painted from life, in the great Academic tradition, the model was, like most of Bravo's subjects, someone the artist knew from his home in Tangier, Morocco, where the predominant Islamic religion prevented women from posing for him. The jeans, boots, and visor tossed to the floor are an independent still life, providing the artist with a means to include an impressive, traditional study of the play of light on inanimate surfaces. Yet the objects themselves, and their proximity to the nude figure, suggest that they belong to the man who now stands naked before the artist and before us, giving the composition a restrained but suggestive erotic quality. Despite the figure's gaze, this is far from a confrontational or graphically disturbing work; instead, the play of light on the model offers the viewer

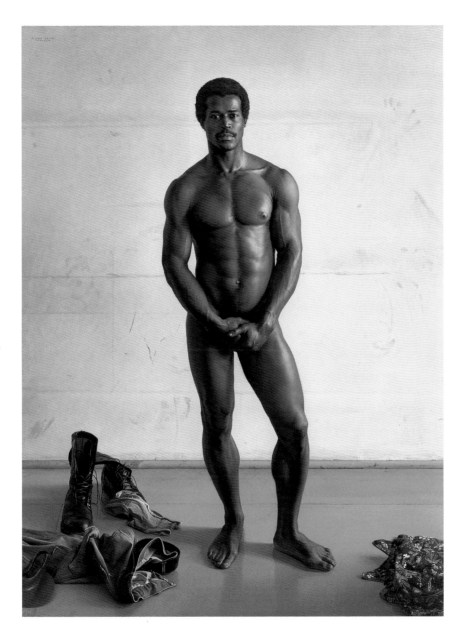

Claudio Bravo, *Portrait of Mr. Couchez* (1978)

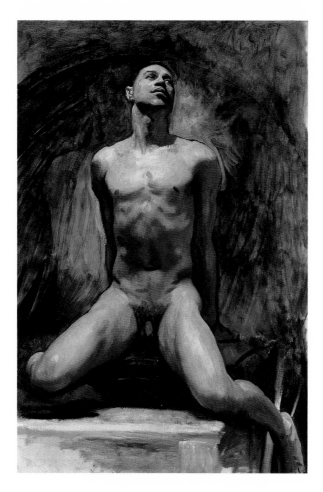

John Singer Sargent, *Nude Study of Thomas E. McKeller* (about 1917–20)

an impressive display of heroic strength and classical beauty, more in keeping with the Roman *Torso of a Youth* or, perhaps, the *Nude Study of Thomas E. McKeller* by John Singer Sargent in the MFA's own collection. It is significant to note that in the late 1970s, when *Portrait of Mr. Couchez* was painted, the human figure was virtually absent from the

56

primary movements in art and critical thinking. More importantly, the male nude was still a marginalized subject. While advertisements today regularly include nude male and female models in openly sensuous arrangements, the appearance of the unclothed male body was still not socially or culturally accepted at that time.

Vanitas (1981) is one of the masterpieces of Bravo's career, and reveals not only his reverence for seventeenth-century Spanish painting but also a glimpse into the artist's world. In 1972, he left behind the frenetic pace of Madrid and moved to Tangier, looking for greater solitude and the opportunity to concentrate on his work. The quality of Mediterranean light was particularly appealing, as was an environment that appeared to be from an earlier time. Simply observing his immediate world led Bravo to the depiction of a very different view, one filled with paradoxes and, to many viewers, a marked theatricality. Yet the figures portrayed in *Vanitas* are simply the caretaker of Bravo's home and his son, Mohammed, typically attired. Their poses, and the introduction of an elaborate and highly symbolic still life placed between them, suggest the painting's title theme, the transitory nature of our existence and the insignificance of worldly possessions. Bravo appears to reference two historical Spanish paintings in this work: The seated, sleeping

figure and the arrangement on the nearby table are related to a seventeenth-century canvas, *The Knight's Dream* by Antonio de Pereda, while another, *Vanitas,* painted in the Baroque period by Juan de Valdés Leal, provides a bubble-blowing angel, laurel-wreathed skull, and coins — all essential to Bravo's allegorical composition.[9]

In this and all of his paintings, the symbolic meaning of the artist's chosen objects is enhanced by his handling of light. As he notes: "My still-lifes are often very close to Spanish seventeenth-century *bodegones.* In many of my still lifes, especially in the large *Vanitas* and others, every element is a symbol of something in life. Symbolism is one of the painter's languages. It helps us to see the hidden . . . The objects I paint often transcend and magnify reality a bit. I use light somewhat in the way that Zurbarán did. He was one of the few painters that gave true transcendent meanings to objects."[10]

Since the creation of *Vanitas* in 1981, the American art scene has experienced a return to figurative painting, although the much more gestural and aggressive style of painting — especially painting coming out of Germany, Italy, and the United States in the 1980s — stands in contrast to Bravo's use of draftsmanship to create a precise, linear style that gives his figures and objects an idealized appearance. In a 1998

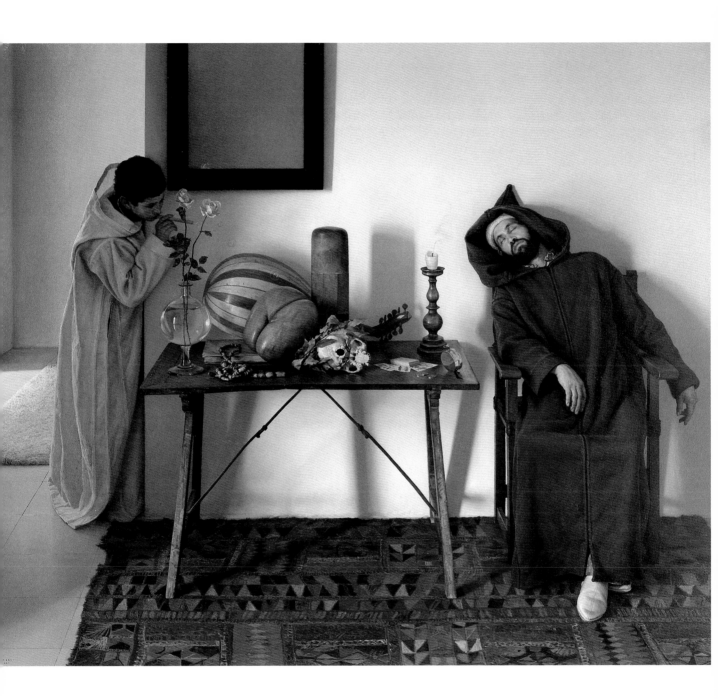

Claudio Bravo, *At the Gallery* (1980)

PREVIOUS PAGE: Claudio Bravo, *Vanitas* (1981)

review of Bravo's paintings, the critic Christian Viveros-Fauné summarized the exceptional characteristic that must also have appealed to Blake and Purnell: "Rather than fool the eye into believing they represent the real, Bravo's pictures, especially the still lifes, hold us by their unreality. It is ultimately the highly conceptualized and willfully formalized character of their fiction, their elaborate artifice, that draws us into them."[11]

Larry Rivers, *Joseph* (1954)

IN STARK CONTRAST to the precision of Claudio Bravo or the atmospheric effects of the Spanish Realists, the compositions of Larry Rivers are characteristically part drawing, part painting, and ultimately give the impression of being unfinished and spontaneous. A successful musician before he became a student of Hans Hofmann in the late 1940s, Rivers, like others of his generation, felt the burden of the gestural painting style of the Abstract Expressionists, which pervaded New York and the international art scene at the time. Unlike most of his peers, however, he developed compositions in which he incorporated representational elements within obvious, painterly passages achieved by applying transparent washes of color. The remnants of brushed and dripping paint maintain a spontaneous appearance and give evidence of the artist's process, in proximity to the exceptional illusion of figures created from the same material. By this date, Rivers had already earned some notoriety for taking on a sacred historical theme and narrative in *Washington Crossing the Delaware* (1953). The work was received with both confusion and respect, and was intended

by the artist as a means of aligning himself with the tradition of historical painting that he had admired in his travels abroad. Rivers's irreverence, and his desire for attention, were not only personal characteristics, they also informed his subject matter. *Joseph* (1954) is a portrait of the artist's stepson at the tender age of fourteen. Unclothed except for his heavy white socks, he stands in a cluttered room staring directly at the viewer, both the clutter and his naked form rendered with line and washes. *Bedroom* (1955) is equally revealing and provocative, especially for its time. A standing man and seated woman appear undisturbed by the painter's intrusion into a room traditionally considered personal and not open to public display; and Rivers heightens the boldness of his choice of subject by having his models direct their unabashed gaze at us.

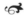

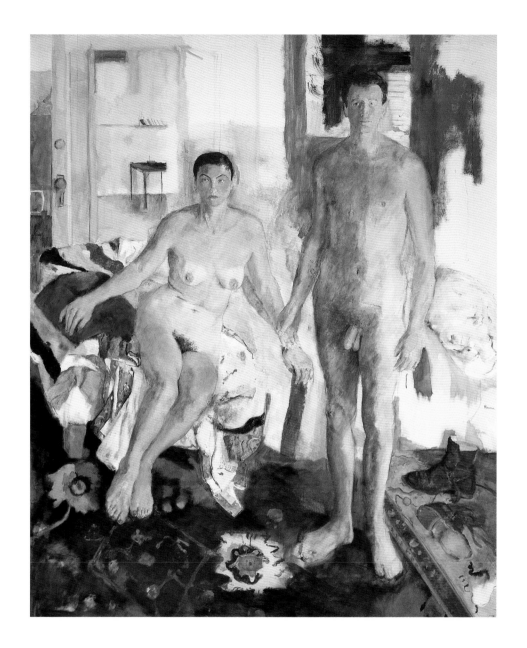

Larry Rivers, *Bedroom* (1955)

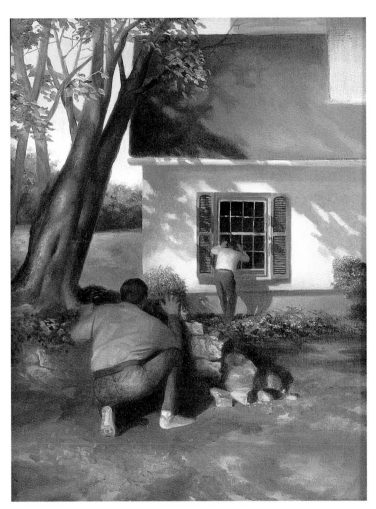

Vincent Desiderio, *View of the City* (1989)

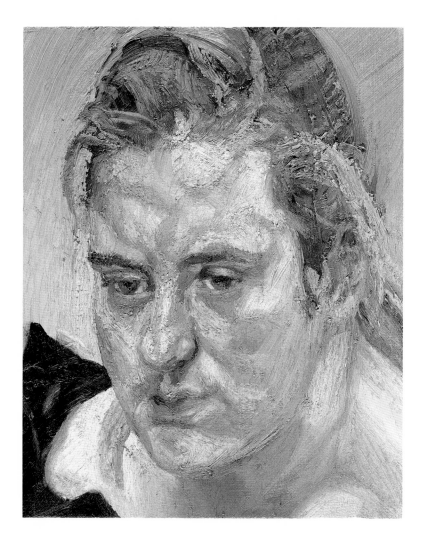

Lucian Freud, *Susie* (1988)

ONE OF THE MOST respected artists working in the figurative tradition today is Lucian Freud. Blake and Purnell originally acquired two exceptional canvases directly from the artist, including a portrait of his youngest daughter, Susie. The same complexity of subtle gradation of tones found within the artist's larger studies of bared bodies is evident in this life-sized head. The weight of Susie's pensive expression is physically mirrored in the heavily painted surface, which would be incomplete if even one of these paint-laden brushstrokes were to be removed. The resulting presence of this intimate painting exceeds its dimensions.

The two quiet drawings by the eccentric Count Balthazar Klossowski de Rola (1908–2001), better known as Balthus, are not typical of his paintings in which adolescents and adults play out scenes underscored by an erotic and troubling tension. Rather, these works were created during the period when he served as director of the Académie de France at the Villa Medici in Rome, and oversaw the renovation of the landmark building. The classical qualities of the archi-

tecture, frescoes, and sculpture that surrounded Balthus are found in these simple studies. Both compositions, like many others in the Blake–Purnell Collection, show models who are at ease with their settings and their nudity. The later study of a young woman in profile, rendered in pencil in a spontaneous manner, appears to have acquired the patina of age (achieved by the artist's physical manipulation of the paper support), calling up the worn surfaces of a fresco.

While many of the human figures in this collection show a kind of classical perfection, a striking exception lies in the work of Fernando Botero, who ignores the imperfections of reality and has instead created a blatantly unreal, highly stylized, and, by now, widely known version of the human form. Characterized by a rotund physique with narrow head and feet, Botero's *Venus* is sculptural in two dimensions and inescapable in three. She does not embody the unobtainable qualities of idealized Classical beauty but harkens back to such figures as the Venus of Willendorf (15,000–10,000 B.C.), a small stone sculpture that symbolized fertility through exaggerated hips and rounded forms.

These same qualities are the vehicle for a study in painting sculptural form, *Vestito a fiori azzurri* (1964) by the Italian artist Domenico Gnoli (1933–1970), who worked as a stage designer and illustrator before

concentrating on painting in the last decades of his short life. Still relatively unknown in this country, Gnoli gained recognition in Europe for his attention to ordinary objects, which he depicted with ambiguity through his distinctive cropping of shapes and his use of light to define form. And while many American artists emphasize images taken from popular culture, he found his subject matter in familiar, domestic objects, such as clothing. In *Vestito a fiori azzurri*, the rounded shape of a woman's behind becomes the vehicle for a study in light and texture. The silhouetted form dominates the composition, exceeding the boundaries of the painting's edge and creating a tension that is both formal and humorous. Gnoli uses trompe l'oeil techniques to create a believable wrinkled effect in the pattern of the fabric stretched across his subject. The addition of sand to the paint brilliantly plays with the tactile qualities of the object, suggested not only by the illusion of this particular form but also by the actual appearance of the surface.

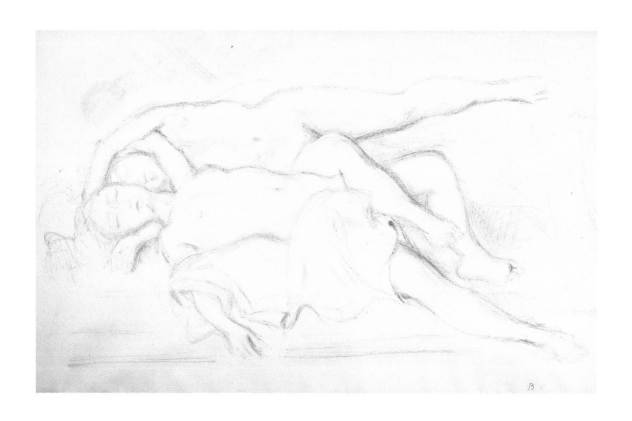

Balthus, *Two Reclining Nudes* (1967)

OPPOSITE PAGE: Balthus, *Nu de profil* (1977)

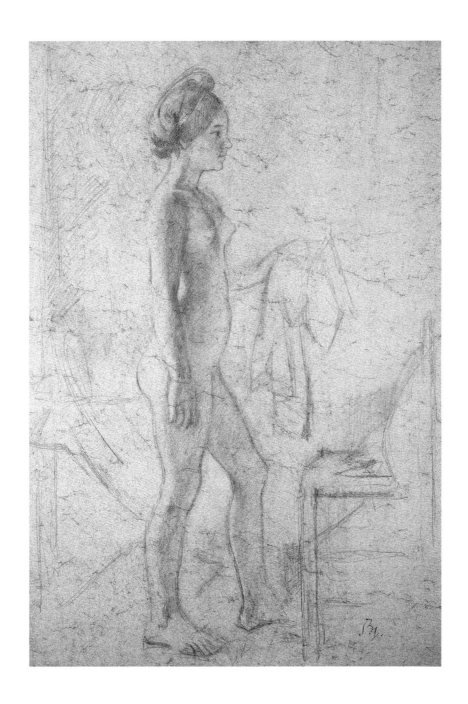

73

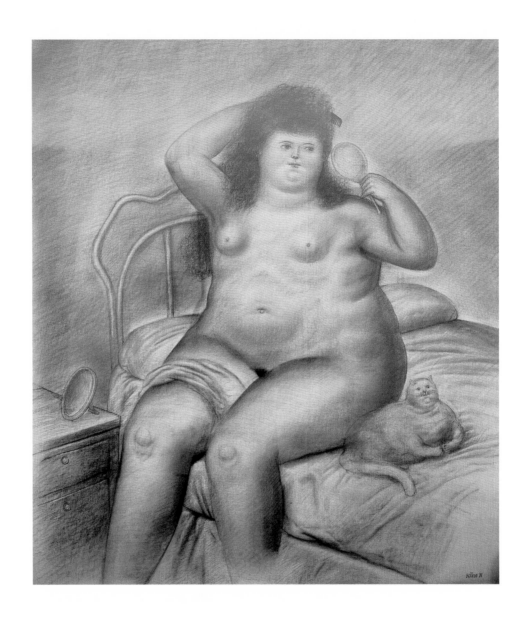

Fernando Botero, *Venus* (1971)

OPPOSITE PAGE: Fernando Botero, *Venus* (1977–78)

74

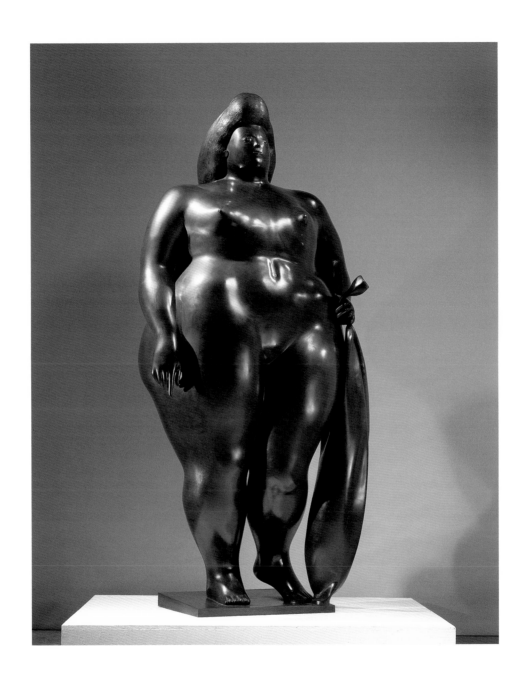

Domenico Gnoli, *La Tasca della giacca* (1966)

Domenico Gnoli, *Vestito a fiori azzuri* (1964)

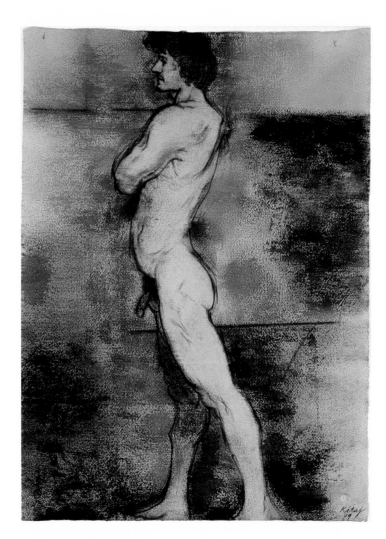

R. B. Kitaj, *Richard* (1979)

THESE WORKS AND THE MANY others collected by Melvin Blake and Frank Purnell richly enhance the holdings of paintings, drawings, and sculpture in the Museum of Fine Arts, Boston. Their addition contributes to the transformation of the permanent collection, as we increase attention to the latter half of the twentieth century and move into the twenty-first. Through these acquisitions, we receive our first examples of Surrealist art and the first representation in our collections of numerous individual artists, both American and European. In some cases, precedents for these artists' works already abound in the MFA's collection. In many others, our collection has been distinctly broadened. The notable representation of paintings and drawings by the primary Spanish Realists, for example, including the work in all media by Antonio López García, as well as the paintings and drawings of Claudio Bravo and Fernando Botero's *Venus*, expand the Museum's modest holdings of twentieth-century Latin American art. The addition of Classical sculpture complements an area in which the MFA excels, while examples of modern abstract sculpture strengthen a recognized area of

weakness. Our representation of American painting of the 1950s is greatly enhanced by the canvases of Larry Rivers. The penetrating portrait by Lucian Freud and a charcoal figure study by R. B. Kitaj join numerous examples of portraiture from earlier centuries, as well as paintings and works on paper by their British contemporaries.

Passionate collectors can dramatically affect a public institution through their own enthusiasm, vision, and willingness to share the art they have lived with. Since its inception, the MFA has consistently benefited from such generosity. Distinguished for its singular vision and emphasis on the human form, as well as for its concentration on contemporary artists associated with the school of Spanish Realism, the Blake–Purnell Collection of drawings, paintings, and sculpture has significantly enhanced the Museum's permanent holdings, contributing to the story already unfolding in our galleries of art from around the world and over the centuries. The Blake–Purnell Collection will continue to resonate as we explore these outstanding examples from the twentieth century through their relationships with the complex and extraordinary art of the past.

NOTES

1. Phillip Bruno of Marlborough Gallery, interview by author, New York, May 2002.

2. Melvin Blake and Frank Purnell, "Thoughts on the Collection," in *Figure and Form: Present, Past and Personal. The Collection of Dr. Melvin Blake and Dr. Frank Purnell* (New York: Millwood Publishing, 1994), 202–4.

3. Gisèle Ollinger-Zinque, "The Making of a Painter-Poet," in *Paul Delvaux 1897–1994.* Exh. cat. (Brussels: Royal Museums of Fine Arts of Belgium and Wommelgem: Blondé Artprinting International, 1997), 14–27.

4. William Dyckes, "The New Spanish Realists," *Art International*, v.17 (Sept. 1973), 29–33.

5. Antonio López García, interview by Michael Brenson, in Michael Brenson, F. Calvo Serraller, and Edward J. Sullivan, *Antonio López García* (New York: Rizzoli, 1990), 307–39.

6. Ibid., 315.

7. Dyckes, "New Spanish Realists," 31.

8. Claudio Bravo, interview by Edward J. Sullivan, in Edward J. Sullivan, *Claudio Bravo: Painter and Draftsman*. Exh. cat. (Madison, Wisc.: Elvehjem Museum of Art, 1987), 28.

9. Sullivan, *Claudio Bravo,* 16.

10. Bravo, interview by Edward J. Sullivan, 27.

11. Christian Viveros-Fauné, "Claudio Bravo: Marlborough Gallery," *Art Nexus* 30 (Nov. 1998), 147.

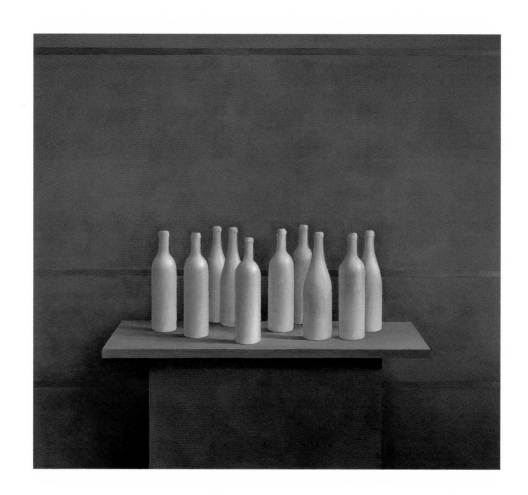

Akira Arita, *Ten Bottles* (1980)

The Melvin Blake and Frank Purnell Collection
in the Museum of Fine Arts, Boston

Note: Works illustrated in this book are indicated by a page number after the title

[Anonymous]
Torso of a Youth [page 14]
Roman, 2nd–3rd century A.D.
Bronze
28 x 18 x 15 in.
2003.47

Akira Arita
Ten Bottles, 1980 [page 82]
Oil on canvas
31½ x 35½ in.
2003.23

Balthus
Two Reclining Nudes, 1967 [page 72]
Pencil on paper
15¼ x 24¼ in. (24 x 33 x 2 in. overall)
2003.1

Nu de profil / Nude in Profile, 1977 [page 73]
Pencil on paper
39⅜ x 27½ in. (46 x 34¼ in. overall)
2003.2

Harry Bertoia
Marsupial, 1963
Bronze
12 x 21½ x 17 in.
2003.48

Sound Sculpture, 1970
Bronze and nickel alloy
Height: 51 in.
2003.49

Fernando Botero
Venus, 1971 [page 74]
Charcoal on canvas
72 x 64 in.
2003.24

Venus, 1977–78 [page 75]
Bronze, edition 3/6
72¾ x 33½ x 25 in.
2003.50

Claudio Bravo

Can You Package Air?, 1969
Conté on paper
28 x 39 in. (39 ¾ x 51 ¼ in. overall)
2003.7

Homage to St. Theresa, 1969 [page 52]
Oil on canvas
59 ½ x 78 in.
2003.25

Stones, 1971
Pastel and conté on paper
69 x 49 ¼ in. (69 ¼ x 49 ½ in. overall)
2003.9

Little Cat II & Big Cat II (Cats), 1976
Mixed media on paper
21 x 17 ½ in. (27 x 23 ½ in. overall)
2003.5

David in Leather Jacket, 1978
Conté on paper
10 ½ x 9 in. (17 x 15 ½ in. overall)
2003.4

Fire Island, 1978
Mixed media on paper
14 x 20 in. (18 x 24 in. overall)
2003.8

Study for *Portrait of Mr. Couchez*, 1978
Conté on paper
6 ½ x 11 ½ in. (11 ½ x 16 ¼ in. overall)
2003.3

Portrait of Mr. Couchez, 1978 [page 55]
Oil on canvas
78 ½ x 59 in.
2003.28

At the Gallery, 1980 [page 60]
Oil on canvas
79 x 59 ¹⁄₁₆ in.
2003.26

Vanitas, 1981 [page 59]
Oil on canvas
78 ¾ x 94 ⅝ in.
2003.29

Interior with Landscape Painter, 1989 [page 2]
Oil on canvas
78 ½ x 60 in.
2003.27

Roman Jars, 1991 [page 50]
Pastel on paper
29 ½ x 43 ½ in. (38 ¼ x 51 ¾ in. overall)
2003.6

Rafael Cidoncha

Self Portrait, 1978
Pencil on paper
19 x 14 ½ in. (25 ½ x 20 ½ in. overall)
2003.10

Pregnant Nude, 1982 [page 48]
Oil on canvas
29 x 36 ½ in.
2003.31

Self Portrait, 1992 [page 49]
Oil on canvas
6 ¼ x 8 ½ in.
2003.30

Xavier Corbero

White Episode, 1974
Almeria white marble and stainless steel
Base: 19 ¾ x 19 ¾ in.; sculpture: 11 ½ x 17 in.
2003.51

Paul Delvaux

Rose et blanc / Pink and White, 1929 [page 19]
Oil on canvas
41 ½ x 50 ⅜ in.
2003.34

Proposition diurne (La femme au miroir) /
 Daytime Proposition (Woman with a Mirror),
 1937 [page 18]
Oil on canvas
41 ½ x 50 ¼ in.
2003.32

Le Printemps / Spring, 1961 [page 16]
Oil on canvas
47 x 54 ½ in.
2003.33

Vincent Desiderio

View of the City, 1989 [pages 66–67]
Oil on canvas (triptych)
17 ½ x 13 ½ in., 17 ½ x 22 in, 17 ½ x 13 ½ in.
 (22 x 56 in. overall)
2003.35

Francisco Farreras

Untitled, 1970
Mixed media on board
39 ⅜ x 31 ½ in.
2003.36

Lucian Freud

Susie, 1988 [page 68]
Oil on canvas
10 ¾ x 8 ¾ in.
2003.37

Domenico Gnoli

Vestito a fiori azzurri / Dress with Blue Flowers, 1964
 [page 77]
Oil and sand on canvas
38 x 43 ¾ in.
2003.39

La Tasca della giacca / Jacket Pocket, 1966 [page 76]
Oil and sand on canvas
43 x 55 in.
2003.38

Julio Hernandez

La Primavera / Spring, 1970 [page 13]
Wood carving
18 ¾ x 29 ½ in.
2003.52

Tesoro de Marcella / Marcella's Treasure, 1971 [page 38]
Bronze
13 x 14 x 10 in.
2003.53

R. B. Kitaj

Richard, 1979 [page 78]
Pastel and charcoal on paper
30 ¼ x 22 in. (41 ½ x 33 in. overall)
2003.11

Carmen Laffon

Maria, 1972–73 [page 46]
Charcoal on paper
60 ½ x 95 ¼ in. (63 x 97 in. overall)
2003.12

Leroy Lamis

Construction No. 79, 1965
Plexiglass construction
18 ⅝ x 4 ¼ x 4 ¼ in.
2003.54

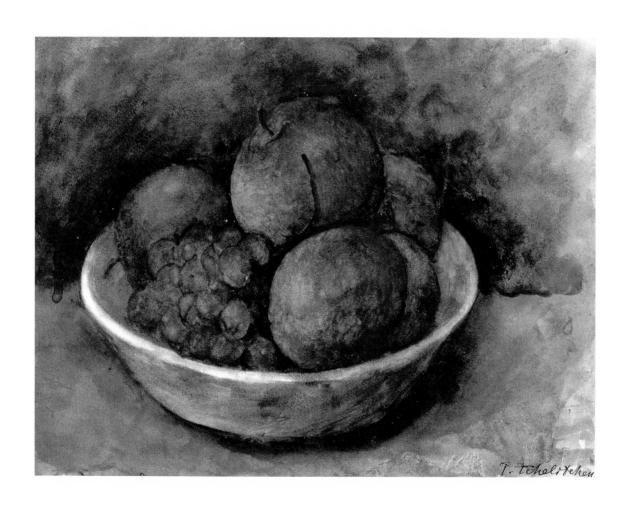

Pavel Tchelitchew, *Bowl of Fruit* (1927)

Guillermo Lledo

Landscape, 1973 [page 43]
Watercolor on paper
25 ½ x 37 in. (32⅛ x 44⅛ in. overall)
2003.15

Antonio López García

Ataud (Niña muerta) / Dead Girl, 1957 [page 33]
Oil on canvas
35 ½ x 42 ½ in.
2003.43

*La Fresquera (Bodegon) / The Pantry (Cupboard
 Cooler)*, 1960–63 [page 36]
Polychromed wood
25¾ x 39½ x 4 in.
2003.55

Percha con ropa / The Clothes Rack, 1963–64 [page 35]
Polychromed wood
58 x 49 x 11 in.
2003.56

Study for *Hombre / Backs*, 1963 [page 25]
Pencil on paper
10 ½ x 7 ½ in. (18¼ x 15¼ in. overall)
2003.13

Hombre y mujer / Backs (Man and Woman), 1964
 [pages 26–27]
Oil on wood
42 x 63 in.
2003.40

Study for *Atocha*, 1964 [page 32]
Pencil on paper
9 x 13 in. (18¾ x 22 in. overall)
2003.14

Atocha, 1964 [page 31]
Oil on wood
37 x 41 in.
2003.42

Lavabo y espejo / Sink and Mirror, 1967–68 [page 34]
Oil on wood
38 ½ x 33 in.
2003.41

René Magritte

Les Graces naturelles / The Natural Graces, 1942 [page 20]
Gouache on paper
16⅜ x 23⅜ in. (24¾ x 32 in. overall)
2003.16

Javier Marin

*Hombrecito de pie rojo oscuro / Little Man with Dark Red
 Foot*, 1997
Oxaca and Zacatecas clay
38⅝ x 15¾ x 13 in.
2003.57

Lucio Muñoz

La Porta / The Door, 1965 [page 42]
Carved and painted wood
25½ x 32 x 2 in.
2003.58

Masayuki Nagare

Small Bachi III, 1973
Black granite with grey granite base
31¾ x 10¾ x 6 in., including mount
2003.59

Matias Quetglas

Poppy Field, 1971 [page 45]
Watercolor on paper
11⅜ x 9¾ in. (20 x 18¼ in. overall)
2003.17

Garbonzo, 1978 [page 44]
Pencil on paper
10 x 10 in. (16¼ x 15¾ in. overall)
2003.18

Isabel Quintanilla

Entry, 1970 [page 47]
Pencil on paper
9½ x 7½ in. (22½ x 18⅝ in. overall)
2003.20

Quince Tree, 1970
Pencil on paper
30 x 22 in. (39½ x 31½ in. overall)
2003.21

Sewing Machine, 1970
Pencil on paper
8¾ x 11½ in. (19 x 16 in. overall)
2003.19

Larry Rivers

Joseph, 1954 [page 62]
Oil on canvas
53¼ x 46¼ in.
2003.45

Bedroom, 1955 [page 65]
Oil on canvas
85 x 71½ in.
2003.46

Birdie and Joseph, 1955 [page 8]
Oil on canvas
13 x 25 in.
2003.44

Pavel Tchelitchew

Bowl of Fruit, 1927 [page 86]
Watercolor on paper
9¾ x 13 in. (18 x 21 in. overall)
2003.22

Raul Valdivieso

Pajaro / Bird, 1986
Grey marble
11¼ x 13¼ x 4 in.
2003.60

OTHER WORKS:

Claudio Bravo, *Mel,* 1974 [page 11]
Mixed media on paper
13½ x 11½ in.

Claudio Bravo, *Frank,* 1974 [page 11]
Mixed media on paper
13 x 9¼ in.

John Singer Sargent, *Nude Study of Thomas E. McKeller,*
 about 1917–20 [page 56]
Oil on canvas
49½ x 33¼ in.
Museum of Fine Arts, Boston 1986.60
Henry H. and Zoe Oliver Sherman Fund